DI006629

GARGOYLES

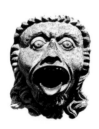

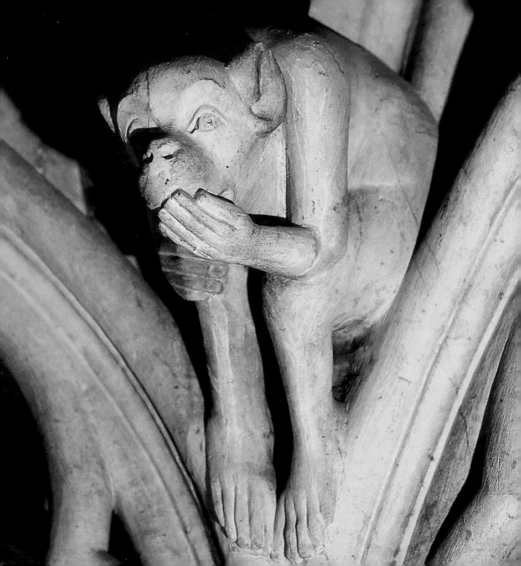

A LITTLE BOOK

OF

GARGOYLES

Text and Photography by
Mike Harding

AURUM PRESS

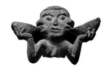

First published by Aurum Press Ltd,
25 Bedford Avenue, London WC1B 3AT

Text and Photography copyright © 1998
Mike Harding

A catalogue record for this book is available
from the British Library

ISBN 1 85410 561 2

Printed in Belgium by Proost

Facing title page – Ape, York Cathedral
Title page – Cat Head, Oxford
Above – Janus Head, Carlisle
Opposite – Screaming Man, Oxford

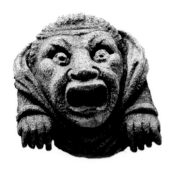

Hob Goblin, Bugaboo
And Boggart, Jenny Greenteeth,
Old Nick and the Hag on the Wall,
Devils from the hottest hobs of Hell.
These nightmares carved in the sky
Sliced from the church's flesh,
Are demons cut to vanquish demons,
Sacred monsters, holy horrors
Screaming into space.

Poem by the author

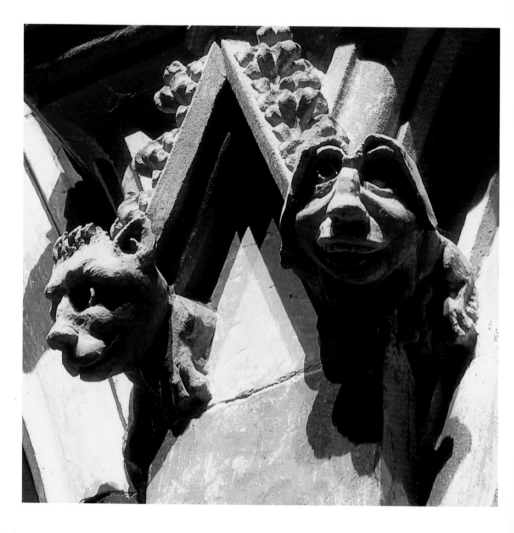

INTRODUCTION

What are these fantastic monsters doing in the cloisters under the very eyes of the brothers as they read? What is the meaning of these unclean monkeys, these savage lions, and monstrous creatures? Surely if we do not blush for such absurdities we should at least regret what we have spent on them?

Bernard of Clairvaux, *Apologia ad Guilb.* Quoted in *Grotesques and Gargoyles* by Sheridan and Ross, David and Charles, 1975.

❖

The nightmarish heads that project from the walls of the medieval cathedrals and churches of Europe and that adorn the temples of India and Nepal serve two functions. Their first purpose is to remind the faithful that there is, ever present beneath the everyday world, another world peopled by monsters, demons and strange beasts, half-man, half-monster; a world close to hell itself which awaits all those who fall into sin. Their second function is apotropaic, they serve to ward off other devils and demons and thus protect the sanctity of the temple or church. This concept may seem strange to us but the medieval mind and the mind of a modern-day Buddhist or Hindu worshipper would see nothing at all unusual in the idea of using demons to ward off other demons.

To thrust Lucifer down into hell, the whole might of the Archangel Michael was necessary. For lesser demons and devils, it was enough that the lower echelons of the nightmare world could be turned, mirror-like, against their brothers, sisters and cousins to drive them away in their turn.

The word gargoyle, used to describe most of the images in this book comes from the French *gargouille* and means 'to gargle'. The word was first used to describe the spouting monsters built into the parapets of medieval

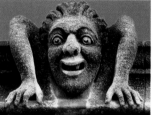

cathedrals to carry off the rainwater that fell upon the vast acreage of their lead roofs and to spew it out far away from the stonework.

The word later came to mean any kind of grotesque, chimera or monster whether carved on the inside or the outside of the church (such as the carvings on this page from Christ's

College, Oxford and, opposite, from Carlisle Cathedral, and it is in both contexts that I use the term in this book. The carvers of the Middle Ages seem to have taken a particular delight in the ugly and the grotesque, perhaps to remind us of the transient nature of beauty and goodness. Nothing that appears in medieval churches came

there by chance, stone carving was too expensive a business for gargoyles to have been mere ornaments, and every image has a didactic as well as a decorative function. The men with the toothache from Wells Cathedral (pp. 66–67) are there not just to finish off the rib of an arch, but to remind us that teeth rot and cause us pain and so, by inference, do the rest of our bodies.

I have included a number of gargoyles from India and Nepal in this book because I suspect that many of

12

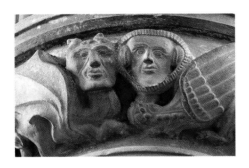

the images we see in the European cathedrals have their origins outside our culture. The tongue-pullers that adorn the walls and capitals of many European churches, for example, have much in common with Kali, the dark Hindu goddess of destruction, who is always shown with her tongue protruding, a symbol of her role as cleanser of the world. Likewise, in ancient Egyptian art the tubby little fertility god Bes is always shown with a protruding tongue.

The meaning that we put upon such images in western European iconography may be very different from their symbolism in India or Egypt. Meanings are culture specific, images are not, and what may look like a horned devil to us may be a shaman or a wise man to another culture. Images of flying gods such as Garuda were appearing in Hindu temples long before they surfaced in Europe as angels and devils.

It is fascinating to think that images of horned and flying creatures, beak-headed monsters and screaming demons that are found on the waterspouts of medieval cathedrals may have had their birth in the religious art of the Indian subcontinent.

Mouth-Pullers

❖

York Minster Chapterhouse

The significance of the gestures and grimaces displayed by many gargoyles and grotesques is lost upon us nowadays, although it is although it is a fair bet that their medieval makers intended something offensive.

Tongue-pulling and nose-rubbing are said by some to have a sexual connotation. The hair-puller and mouth-puller opposite could be designed simply to frighten or amuse, or there might be a deeper lost meaning. Some scholars have suggested that the mouth represents the vagina and that pulling the lips apart is a sexual

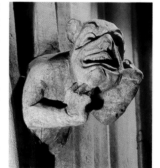

gesture. But what does it signify, invitation or offence? That so many such figures are found in the chapterhouses of the great cathedrals where the dean and chapter would meet to discuss the business of the cathedral implies that the carvings had some serious purpose, perhaps reminding the worthy ecclesiastics that they too were subject to the laws of nature. Like the Fool in his role as Lord of Misrule they were carved to remind the clergy that pride often comes before downfall and that pomposity is an invitation to mockery.

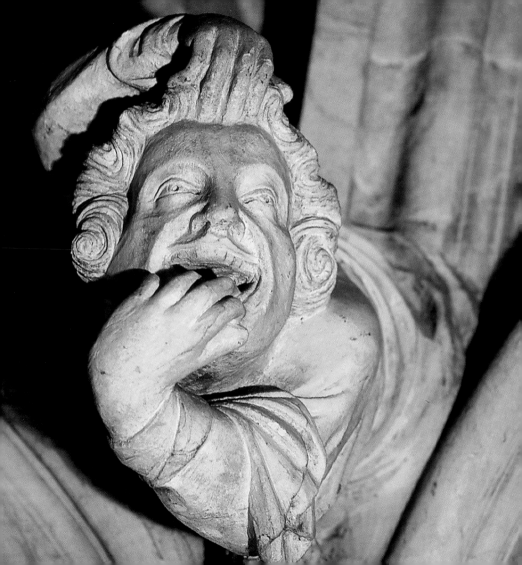

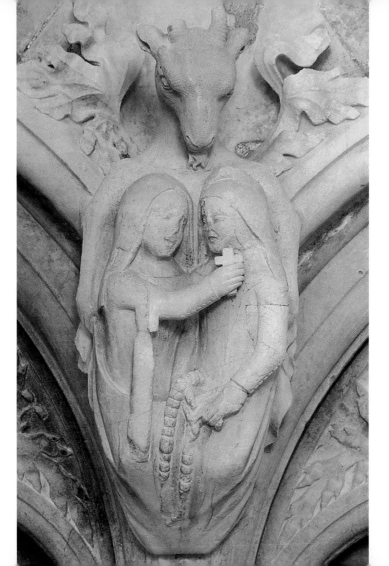

SATAN & NUNS

❖

Beverley Minster, Yorkshire

P art of a truly fine set of carvings, the picture opposite shows two nuns on the verge of what appears to be a sexual encounter. Satan in the shape of a goat, the symbol of lechery and lust, is watching gloatingly over them.

Devils and demons abound in the religious carvings of Europe and the fact that the devil is so often shown as a goat leads me to suspect that the Christian Church made a deliberate attempt to demonize the older religions it supplanted. One of the attributes of the shaman of the pagan European tradition was his horns, a symbol of knowledge and wisdom. No surprise then that Satan should be shown with horns symbolizing the darkness and evil of the old religion.

The carving you see on this page is situated near the one opposite, but these two nuns are singing hymns from a songsheet and are in no danger from Satan and his wiles. There are a great number of bawdy tales, songs and carvings of the Middle Ages that reflect contemporary amusement at the difficulties monks and nuns obviously experienced in sticking to their vows of chastity.

Fountain & Font

Boboli Gardens, Florence, Italy & Wilton, Wiltshire

Spouting water into the fountain of the Boboli Gardens, the feathered head above is a masterpiece of the grotesque in bronze; such heads, sometimes foliate rather than feathered, are to be found on fountains in town and palace squares right across Europe.

The imposing monster's head on the opposite page, with its great brass ring, is one of four that can be seen on a vast baptismal font in the very strange Italianate church in Wilton.

As well as the font, this church also has several monumental second-century Roman columns and a number of sixteenth-century stained-glass windows. The visitor has the sensation of being in a church designed by somebody who was rich, eclectic and entirely devoid of taste.

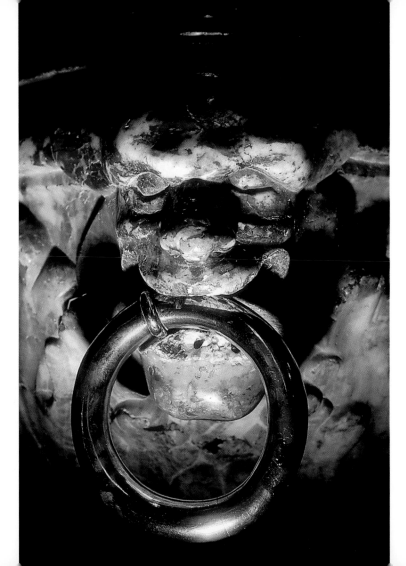

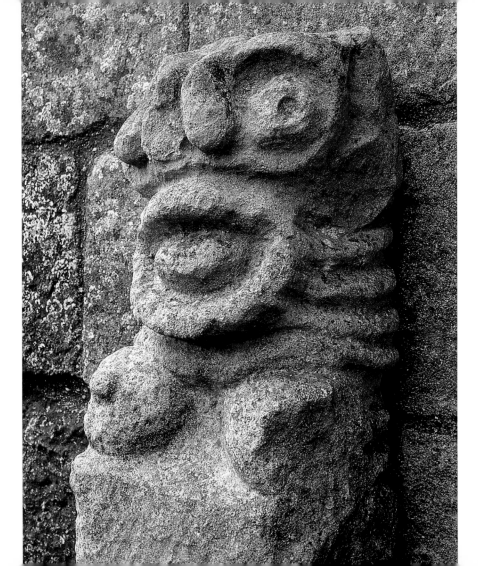

EARTH MOTHERS

❖

Braunston, Rutland & Kilnaboy, County Clare, Ireland

The earth mother appears in many religions as the fount from which all of life comes; in the persona of Gaia, she is the very planet itself.

The onrush of feminism and the reappraisal of history from that viewpoint brought the role of the goddess into more prominence than it had known before. Some historians feel that things had gone too far and that the feminists, who claimed that all societies were matriarchal in their earlier stages, were in danger of overlooking the part that patriarchal societies had played in European history. Perhaps the truth lies

somewhere in between.

But it is certain that representations of women are amongst the earliest prehistoric images and that veneration of the mother would have been a major part of the religion of that time.

The lovely carving on this page from Clare shows the earth mother in her role as Sheila na Gig, the vulva shows evidence of having been rubbed over the years, possibly by women wanting to conceive. The carving opposite, a full-breasted fertility figure; was rescued recently after spending years lying face down in the earth serving as a church doorstep.

SCREAMING MONSTERS

❖

Chester Cathedral

Screaming monsters spewing out water and venom onto the streets and walkways below are the most familiar kind of gargoyle. Warding evil away from the building at the same time as they spout the water clear of the walls, they thus serve at least two functions. But the fact that they are often shown in terror, or causing terror, suggests another role, that of instilling fear in the laity by providing a constant reminder of what the meaning of the building was and what lay in wait for those who ignored that meaning.

Unfortunately, years of exposure to wind and rain, and in recent times to industrial pollution, means that many of the finest carvings in Europe are now reduced to mere shadows of their former selves. The gargoyles here of the man-headed dragon and the screaming woman are part of a series re-cut by Victorian stonemasons.

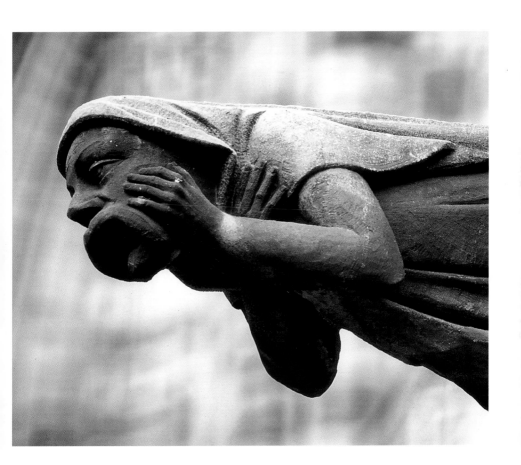

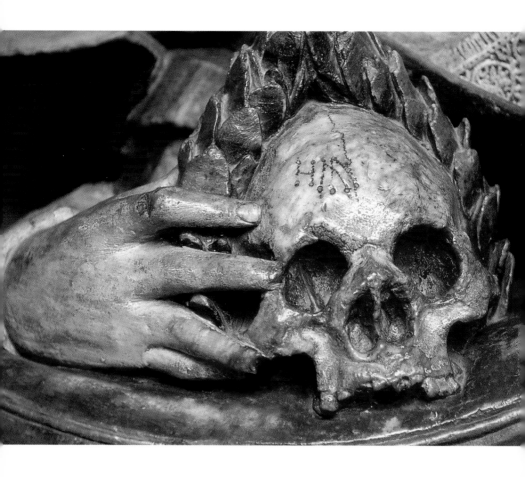

MEMENTO MORI

❖

Exeter Cathedral &
Breedon on the Hill, Rutland

The great plagues that raged across Europe throughout the Middle Ages killed vast numbers of people at a time when life was already thought of as a harsh, cruel and short affair.

The threat of death was ever-present, it may have come from pestilence and famine, or from

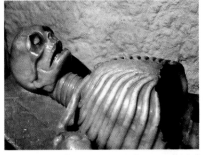

the wars and crusades that moved over Europe and the Holy Land like another form of plague. The proximity of death brought about a fascination with the macabre, almost as though the whole population had become obsessed with their own mortality. The Dance of Death, where Death leads the dancers on to the grave is a common subject in medieval art, while in folk song the Twa Corbies sing of the dead knight they are to feast upon:

I'll sit on his bare breast bone
While you pike out his bonny blue eyes.

This morbid fascination with death and decay led contemporary sculptors to create *memento mori* like the laurel-wreathed skull from Exeter opposite and the finely carved and chillingly accurate alabaster skeleton above.

Men & Serpents

❖

Kirklington, Yorkshire

On the walls of this tiny church are a group of stone monsters whose creation owes more to the carver's imagination than to any bestiary or *Biblia Pauperum*. Where did the ideas for such monsters come from? Are they the stuff that nightmares are made of, visions that came out of the darkness and were made solid by the sculptors hands? Or were they born out of the legends and tales told by the fireside on 'long winter's nights'?

At a time when knowledge of the world outside your village was limited to folk tales and legends and stories brought by travellers and packmen, truth and fantasy often ran together. Travellers' tales would become embroidered and elaborated until it would seem that the world outside was peopled by monsters with their heads in their stomachs and creatures that were half-man, half-snake.

The character opposite is a kind of devil whose horns turn into lizards with paws. The little chap above is an acrobatic snake-man whose tail curves over his head – a merman perhaps?

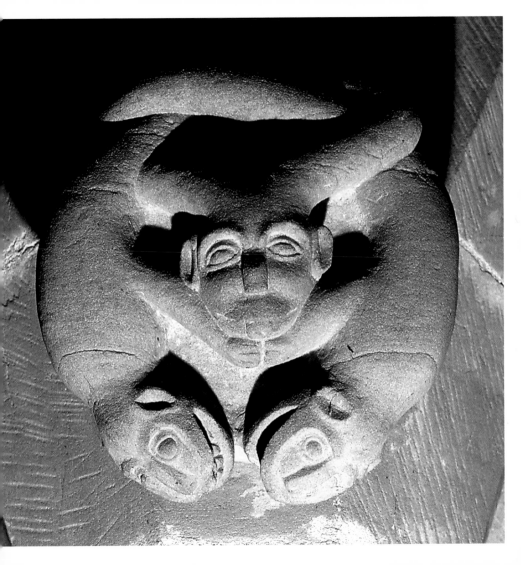

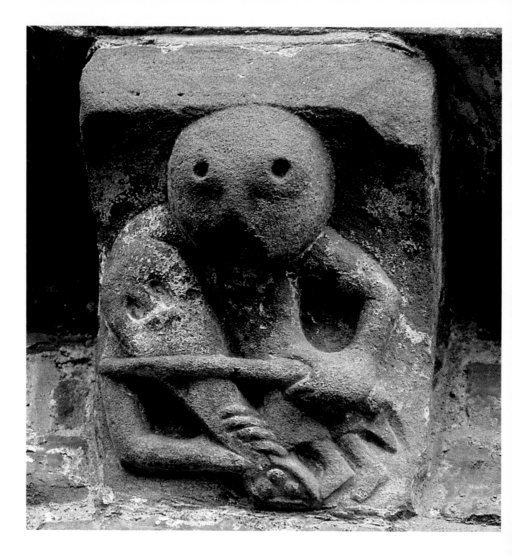

MONSTER MUSICIAN & LOVERS

❖

Kilpeck, Herefordshire

The fine corbel table at Kilpeck was sadly damaged in the last century by prudish clergymen who removed some of the bawdier carvings. Strangely they seem to have ignored the Sheila na Gig on page 43, or did they perhaps miss her significance?

Amongst the many fine carvings that the Victorians spared is the pop-eyed, viol-playing creature opposite who might be warning of the dangers of music, which was seen by medieval

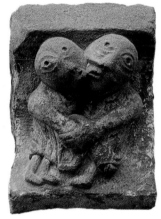

churchmen as a self-indulgent luxury, leading to all kinds of sins of the flesh.

The kissing lovers on this page, whether they be man and woman, man and man, or woman and woman, must surely be intended as another warning against the temptations of the world of the flesh and the devil. Yet they seem very friendly and un-threatening, chummy almost, so perhaps the carver didn't really intend us to take the warning all that seriously.

DEVILS & THE DAMNED

❖

Orvieto, Italy & York Minster

O rvieto has one of the finest cathedrals in Europe: a vast, ornate marble ship sailing through the hills of Tuscany. At its west end, facing the setting sun, is a powerful and very intricate carving showing the damned being led off to hell by a variety of gloating and grimacing demons.

The doom prophesied to take place when Christ sits in judgement at the end of the world was an all-pervading image in medieval art.

The stained-glass windows of many churches show St Michael balancing souls on a pair of scales. The damned souls, dragged down by their sins, are seized by the demons who lead them off to the pit. Later, Hieronymous Bosch brought a pitch of horror to his depiction of the nightmare world of the damned that first appeared in wall paintings and carvings all over Europe during the early Middle Ages.

The carving on this page is part of a wonderful doom stone in the crypt of York Minster which illustrates the grip that images of death and damnation had on the medieval psyche.

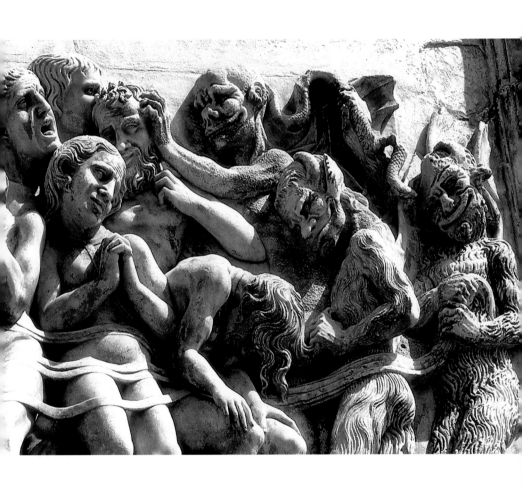

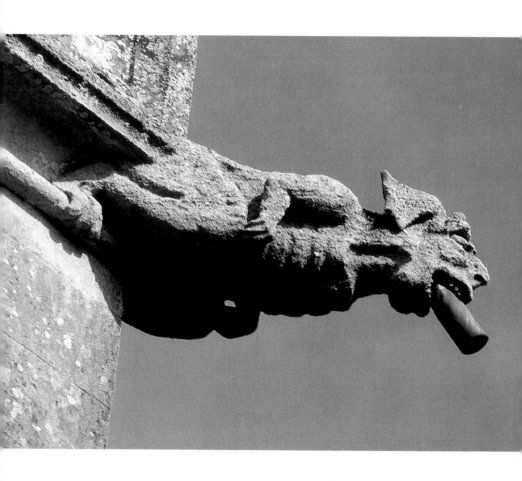

Spouting Heads

❖

Gillingham, Wiltshire
& Sherborne Abbey, Dorset

Taking a walk along the cathedral closes and alleys that encircle and adjoin medieval churches and cathedrals during a rainstorm can be a dismally wet experience if the gargoyles are doing their jobs properly, because the projecting

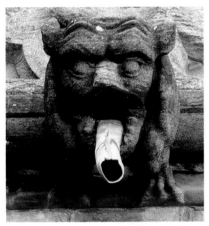

monster will be vomiting several gallons of rain water a second onto the streets below.

The grinning monster on the left from the parish church of St Peter's,

Gillingham is a typical example of a dog-eared man-monster, complete with a well-defined rib cage and a lead gutter spout that allows him to throw the water even further.

The squatting terror on this page, again with his own lead pipe, is from the lovely abbey at Sherborne. He is one of a troupe of gargoyles that serve to clear the waters from the southern part of the lead roof, all in fine fettle and all about as pretty as this little chap.

THE PHARISEE

❖

Beverley Minster, Yorkshire

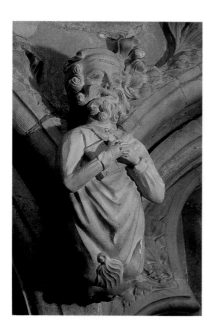

Amongst a group of splendid carvings in the minster at Beverley is the one on this page of a Pharisee. Close by is a scribe prostrating himself in grief for his sins and begging forgiveness.

The Pharisee is evidently proclaiming his holiness, as in the New Testament parable. But when you look closely at the pedestal underneath you see that the tassel of the cushion beneath his knees is in fact the hair-lick of the demon of corruption that lives within the hypocrite. For the cushion he is kneeling on is the leering monster on the page opposite, the real, grim and evil face of his sins and a mirror of the corruption concealed within his soul – a true whited sepulchre.

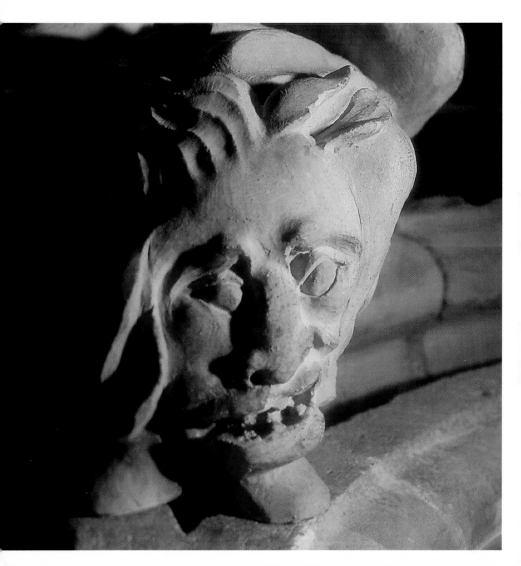

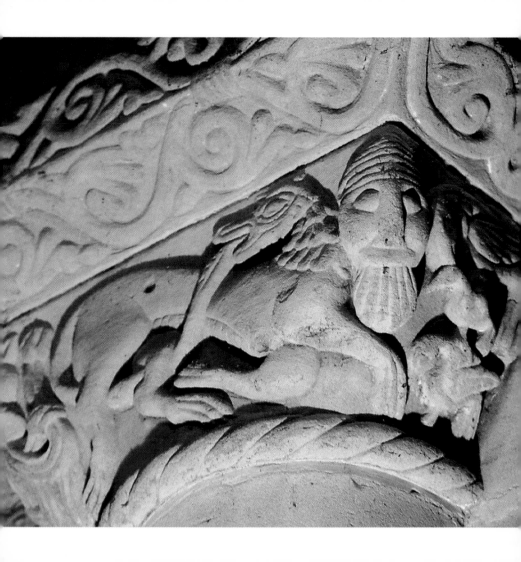

CENTAUR & LION MAN

Rock & Dumbarton, Herefordshire

In the Assyrian rooms in the Louvre Museum, Paris, a wonderful collection of mythical beasts is displayed. Among them are a number of winged lion-men or *lamassu*, gods or guardian deities of the palace doors.

The carving of the creature on the opposite page looks so much like an Assyrian beast that I cannot help but wonder whether the mason had seen similar illustrations; the beard and the headdress in particular seem to owe something to the more ancient Assyrian carvings.

Indian sculptors later adopted the image and turned it into what we now know as the centaur from where it seems to have found its way into Greek and Roman art.

The jolly little centaur on this page from Dumbarton has lost his bow and arrow and one of his arms but has gained a lovely pair of pigtails.

Janus Heads

Carlisle Cathedral &
Cartmel Priory, Lancashire

The tricephalic head is sometimes said to represent the Trinity and this may well be so, though it is more likely that the Christian Trinity was partially inspired by the old pagan idea of the Janus head. At times he appears simply as two heads, one looking back to the past, the other facing forward to the future; at other times he becomes a three-headed form looking to the past, present and future. It was in this aspect of the doorkeeper that Janus gave his name to the month of January.

Such images are quite common in Britain and Ireland and can be found on misericords and roof bosses as well as on corbels. The foliate-spewing, crowned head opposite is from a wonderful collection of misericords in Cartmel Priory. The significance of the crown has been lost in time, and whether the head wears a heavenly or temporal crown is a matter for conjecture.

The drinking heads above from Carlisle are part of an extremely fine set of carved capitals that show the seasons of the year. Janus here seems to be drinking both to the old year and the new while the third face looks calmly ahead into the present.

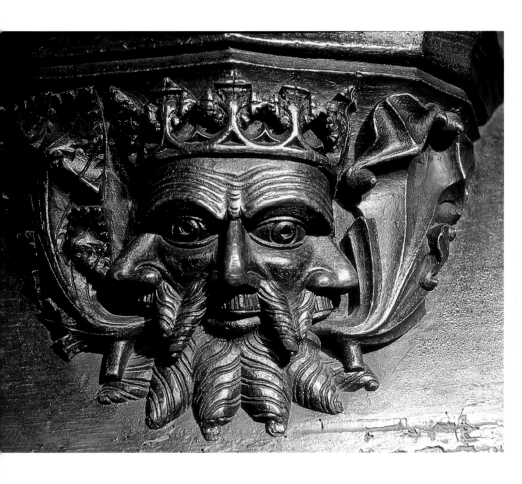

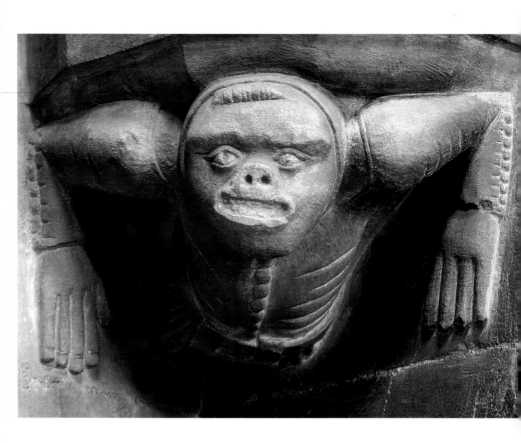

DEMON HEAD & CRETIN IMP

❖

St Mary's, Beverley, Yorkshire

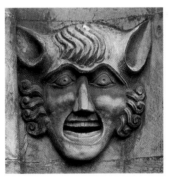

Beverley, a small market town in Yorkshire, has a wonderful minster with a great collection of misericords and fine stonecarvings.

Close by is the smaller but no less beautiful St Mary's which contains some of the finest medieval decoration in England. There are many carvings of the Green Man, the pre-Christian fertility symbol (see the companion volume in this series) and a number of very fine roof bosses. Around the west door is a cluster of heads, some of them Green Men, some, like the fellow above, pure demons, part-animal, part-human in appearance. They served to remind those who entered through the door that all evil must be left behind. Inside the church, on the east wall of the choir, is the figure opposite, a cretinous and threatening imp leering out into space. You can imagine the effect such a figure would have had on the small children of Beverley. No need to frighten them with Jenny Greenteeth or the bogeyman, here was their very own monster, their home-grown bugaboo, and nightmare on the wall.

Sheila na Gigs

Church Stretton, Shropshire & Kilpeck, Herefordshire

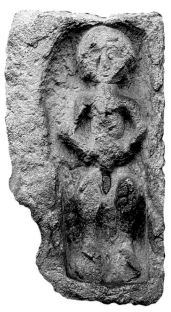

One of the most beautiful and well preserved examples of Romanesque art, the tiny chapel of St Mary, Kilpeck, has as part of its corbel table a selection of truly remarkable images.

The Sheila na Gig shown opposite is one of the best preserved examples in Europe of an image that goes back to the prehistoric Venus of Willendorf: the image of the fertile goddess displaying herself. The medieval mind saw nothing indecent in displays of this kind and indeed looked on the image as so powerful as to warrant special attention.

Of the hundreds of Sheilas in the British Isles many show the marks of centuries of rubbing around the vulva, perhaps indicating that women who wished to conceive have touched the carvings for good luck. Their continued existence to this day is some indication of the power they still exercise upon the imagination.

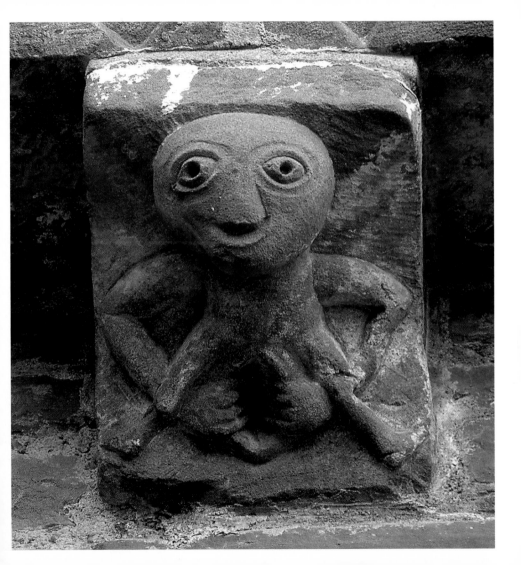

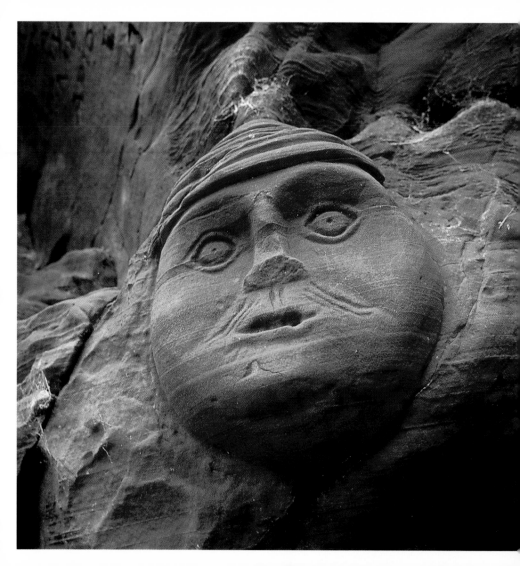

CELTIC HEADS

❖

*Armathwaite, Cumbria
& Cloghane, County Kerry, Ireland*

Whoever the Celts were, they left their mark upon places as far flung as Wales, Cornwall, Scotland and the north-west of England as well as Ireland. The cult of the head featured strongly in their religion, the head being the seat of the soul, and they decorated their gates and doorways with the heads of their defeated enemies.

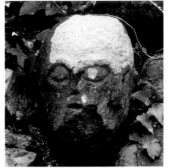

Later, carved wooden or stone heads took the place of the real thing and many such heads have been discovered in sacred wells and rivers both in these islands and on the continent.

The head on this page (now stolen) once stood in the wall of the ruined church at Cloghane under Brandon Mountain, and is said to represent Crom Dubh, the pagan god vanquished by St Brendan from the summit of Kerry's most holy mountain.

Celtic-style heads continued to be carved 'for good luck' long after the Celtic religion died and the head opposite is one of several grotesques carved into the face of the sandstone cliffs at Armathwaite by a man called Mounsey, a Victorian polyglot and eccentric.

SHAMAN & SAINTS

White Island, County Fermanagh, Ireland

On White Island, set in the lovely waterlands of Lough Erne and accessible only by boat, there are a group of powerful carvings. Now displayed within the ruins of a small chapel, they were only recently discovered buried close by. One of the figures, carrying a bell and holding a crozier, is a bishop, others are possibly saints, while the figure at the far end in the picture opposite, shown in more detail on this page, is the most intriguing of all the carvings. Some authorities

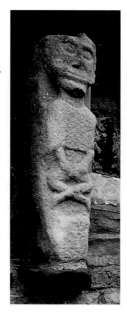

believe the figure to be a Sheila na Gig and cite the hands over the genital area as evidence. Ireland probably has more Sheila na Gigs than any other country in Europe but this, I would suggest, is not one of them. Note the absence of breasts and the figure's cross-legged stance; this, like the lotus position so often seen in Buddhist and Hindu art, indicates that the image had a shamanistic role. The Gundesrup Cauldron shows a similar figure with horns on its head grasping a snake and a torc.

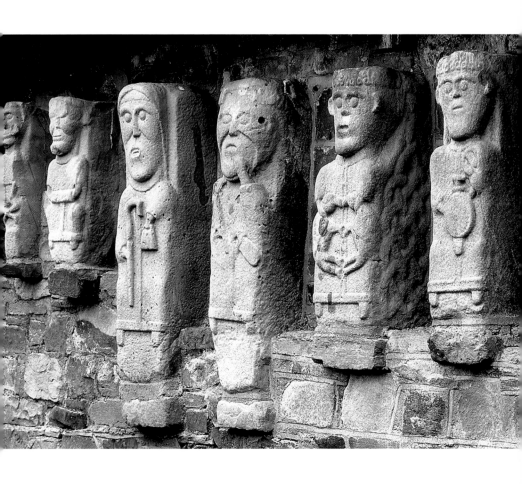

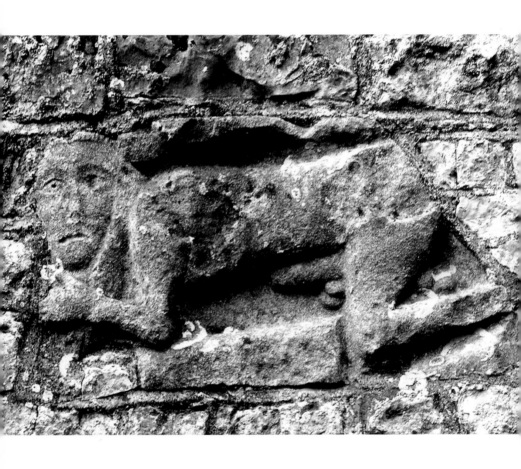

PRIAPIC GIANTS

❖

Abson, Somerset & Cerne Abbas, Dorset

High on the east wall of the parish church at Abson near Bristol is the crouching stone figure you see opposite. Looking a little like Job in Blake's engraving, he crawls across the wall, aroused and ithyphallic.

Nobody quite knows what he is supposed to represent or how he came to be there, though it is assumed that he came from an older building and that he was placed on the wall to ward off evil spirits.

The Cerne Giant shown above is another mystery. Carved into the chalk on the hill above the village of Cerne Abbas he carries a club in one hand like Hercules or a Wodewose – one of the wild men of the forest so often depicted on misericords. The giant is almost certainly a prehistoric symbol of power and fertility.

In living memory, women who wanted to get pregnant would come at night and lie stretched out on the giant's *membrum virile*, and local folklore has it that during the Second World War the carving was covered up because the navigators of German bombers were using the giant's penis as a visual fix to plot their course to the port of Bristol.

TONGUE-PULLERS

❖

*Fairford, Gloucestershire
& Newark, Nottinghamshire*

One of the most striking and mysterious aspects of medieval art is the unwritten world of symbolic code that lies at its very root. There are carvings, for example, showing gargoyles with their hands to their throats, the thumb and palm making a right angle.

For years people puzzled over the meaning of this, until somebody pointed out that journeyman masons employed this gesture as a sign of their craft and that St Blaise, who is the saint associated with diseases of the throat and mouth, is also the patron saint of masons.

After looking at what evidence there is, I am still of the opinion that tongue-pullers are not simply 'making a rude face' but that the grimace has a deeper significance.

The monsters and grotesques pulling tongues may represent death and are descendants of Kali, the death goddess of Hindu mythology who is always shown with a protruding tongue.

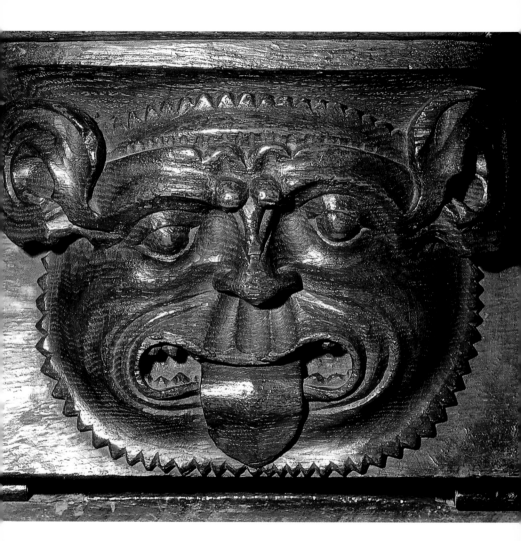

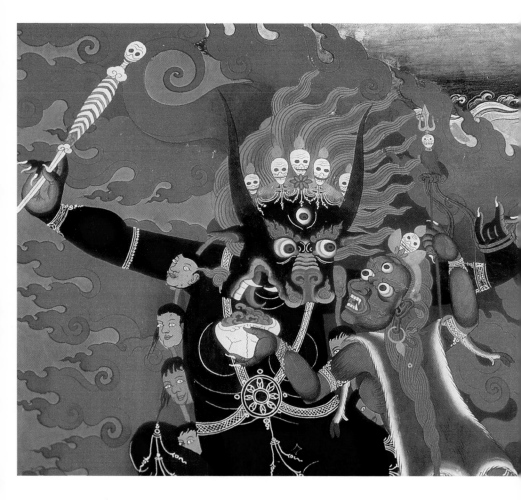

BUDDHIST DEMONS

❖

Dhankar Gompa,
Spiti Valley, Northern India

High in the Himalayas in the Buddhist Monastery of Dhankar Gompa is a group of wall paintings depicting monsters and demons of the Buddhist world.

The God-demon on the left scours the world, dragging those who are tied to the flesh, not down to hell, but back into the world after death to be turned once more on the wheel of sorrow that is life.

The monster above crushing the two humans is a composite made up of the senses – ears, eyes, nose and tongue – a slavish devotion to which will drag us back into the world, to face another life, another turn of the wheel.

The presence of such images of gods and demons on the walls of Buddhist temples seems strange, since Buddhists believe neither in gods nor in the otherworlds of heaven and hell.

However, the monsters and demons are both a hangover from the older Bon religion that preceded Buddhism and a personification of the forces and passions that chain us to the wheel.

BITING MONSTERS

❖

York Minster & Wells Cathedral

Biting, snapping and gnawing monsters are common in many of the cathedrals and churches of mainland Europe, and represent the constant threat of eternal punishment that sinners bring upon themselves.

There are few carvings as horrific as those that show monsters devouring human heads, like the capital from Wells Cathedral on the opposite page. An evil, serpent-like creature squats on the head of a Green Man, devouring him as the Green Man spews out foliage from his mouth. It is hard to determine what this image signifies. Is the Green Man being devoured by a demon or does the serpent represent eternity and therefore the eternal role of the Green Man? More horrible still is the head on this page from the chapter-house at York Minster. Here, a great malevolent bird is ripping out the eyes of the poor sinner, truly the mother of all nightmares, made more horrific by the fact that, like the rest of the chapterhouse, the carving is executed with such great care and skill.

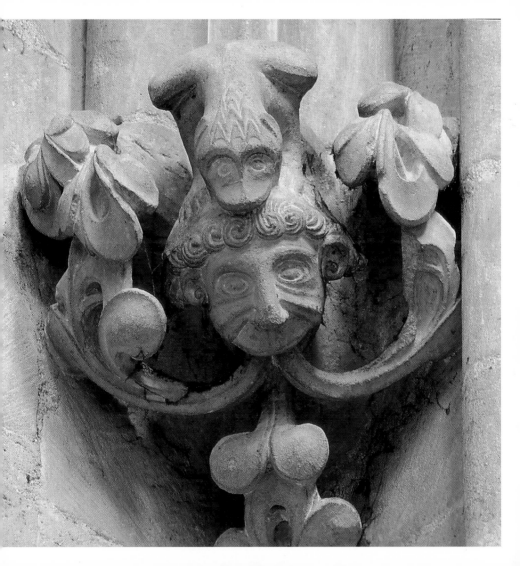

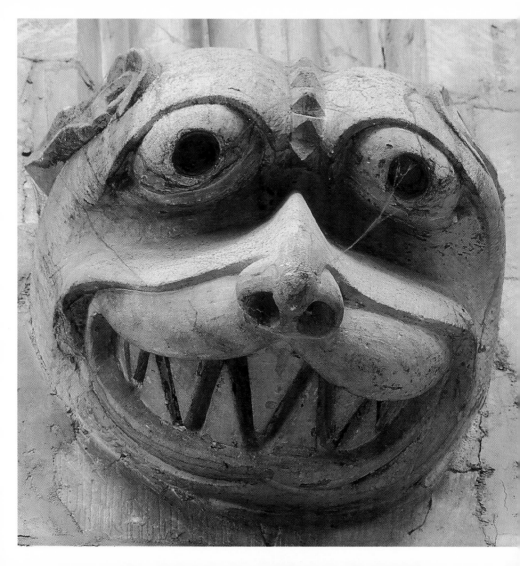

MEDIEVAL MONSTER MOGGIES

❖

Gloucester Cathedral

Cats were seen by the medieval mind as creatures of darkness and the night because of their ability to see in the dark. They were thus associated with Satan – hence the witch's cat or familiar, often shown riding behind her on a broomstick. The image of the lucky black cat would appear to be a relatively modern development.

Nocturnal, independent, a lunar rather than a solar animal, and seen by man as having the essential elements of the female, the cat was worshipped in ancient Egypt as a manifestation of Bastet, the goddess of the moon. The Chinese believed that the cat could banish demons and evil spirits; they also saw it as a symbol of good luck and a bringer of rain.

In medieval Europe, though, the cat was generally demonized, and cat heads such as the two here, from Gloucester Cathedral, show poor puss in her most demonic form, glaring down from the capitals of the great pillars that guard the western end of the nave.

DRAGONS

❖

St Bee's Head, Cumbria & Crowcombe, Somerset

K nown as serpents in the Bible and 'laidly wurms' in Northern English dialect, dragons feature in many different cultures, most of which also have their dragon-slayers. In Christian tradition the best known is St George who famously saved a maiden from becoming a dragon's lunch.

According to some Jungian analysts, the dragon represents the shadow or our darker selves, and George's slaying of it represents a failure to come to terms with the shadow. Much better,

according to other analysts, are the versions of the story in which the maiden leads the dragon to peaceful submission with a lock of her hair, perhaps representing beauty and truth taming the more primitive forces.

Without any maiden's coiffure to help them, the 'dragon-slayers' opposite are coping with a two-headed dragon on a Somerset bench-end while the Anglo-Saxon hero above does battle with a bonny dragon on a gate stone outside the lovely church at St Bee's.

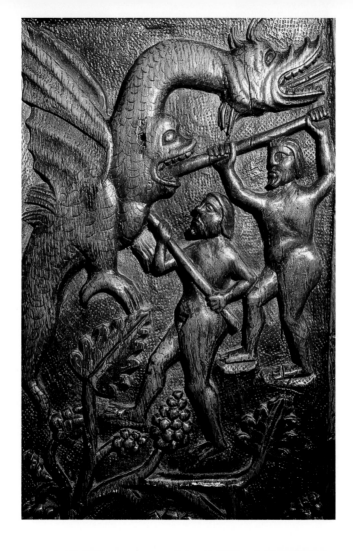

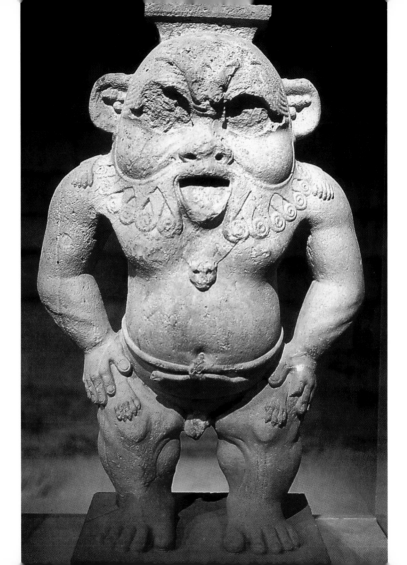

BES & THE BOBOLI MAN

❖

The Louvre, Paris, France & Florence, Italy

Bacchus, the Greek god of wine and his attendant and nurse Silenus, were always shown as pot-bellied men, perhaps implying that fatness is a sign of fecundity. The statue on this page, from the Boboli Gardens in Florence again, shows a full-bellied, dwarf-like deity riding on a tortoise, perhaps Silenus making his slow and dignified way to a Bacchanalia, a festival in 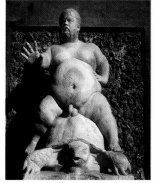 honour of Bacchus. Frazer in *The Golden Bough* describes Bacchic worship as 'wild dances, thrilling music and tipsy excess' and says that it 'appears to have originated among the rude tribes of Thrace who were notoriously addicted to drunkenness.'

The Egyptian god Bes shown opposite was a powerful, much-loved fertility symbol for the ancient Egyptians, and women who wanted to get pregnant would come to Bes and make sacrifices before him to secure his blessing.

While travelling along the Nile a few years ago I was told by a local guide that barren women from the villages still come to rub themselves against the statues of Bes in the temple ruins.

HAGODAY & CLOSING RING

❖

Adel, Yorkshire & Durham Cathedral

On the great doors of many churches, cathedrals and abbeys across Europe you may find sanctuary knockers.

Since the medieval church ran its own affairs independently of the temporal power and had its own laws and territorial rights, it was possible for wrongdoers to take sanctuary within a church and shelter there from the laws of the world outside. After a year and a day in sanctuary, the miscreant could then go free. If criminals were being pursued, it was enough for them to lay their hands on the door of the church.

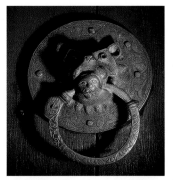

Clutching the ring of the Hagoday, as it was called, they were then able to lay claim to protection under Canon Law.

The lion head from Durham on the facing page is a lovely example of a Hagoday, fierce and glaring. It is a carefully made copy of the twelfth-century original which is now inside the cathedral for safe keeping.

The knocker on this page from the beautiful Norman church at Adel near Leeds, shows a lion or tiger in the act of swallowing a man whose head just peeps from the animal's mouth.

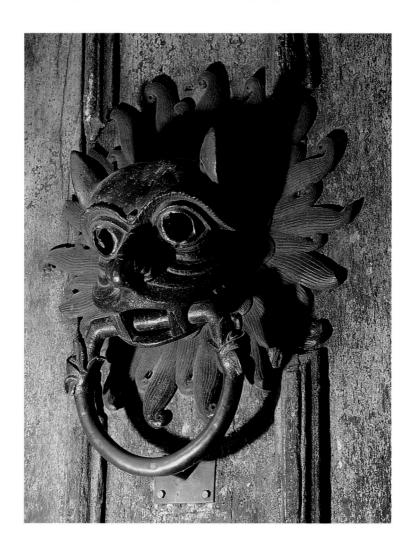

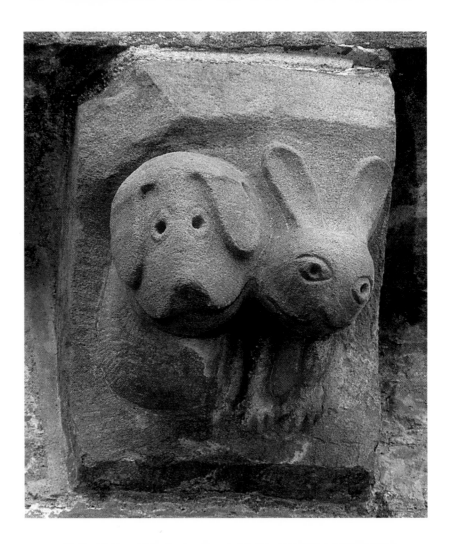

RABBITS & A FRIENDLY DOG

Kilpeck, Herefordshire & St Mary's, Beverley, Yorkshire

Occasionally the stonemasons seem to have taken a day off from carving images of terror or death and to have simply enjoyed themselves. It might seem puzzling that the clergy, who after all were footing the bill, should have tolerated such levity; the explanation lies in the spirit of carnival.

At the root of all medieval thought, there in the cellar amongst the terrors of war, to the plague and hell and damnation was a topsy-turvy world in which everything, including death was mocked. This is the very spirit of carnival, the festival that celebrates

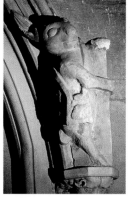

misrule and cocks a snook at the yawning grave that awaits us all. The little creatures here are aspects of that spirit of carnival – the dog and rabbit friends on the opposite page from Kilpeck are a reversal of the normal world, while the pilgrim rabbit on the left, with his satchel and his scallop shell showing that he has made a pilgrimage to Santiago de Compostela, is said to be the model for the White Rabbit in Lewis Carroll's *Alice in Wonderland*. Lewis Carroll's grand-father was rector of St Mary's for a while and it is possible that the author saw the rabbit there as a child.

MEN WITH TOOTHACHE

❖

Wells Cathedral, Somerset

Master masons were known to use apprentices and fellow workers as models for their carvings.

It would seem that the masons of Wells Cathedral were a pretty unhealthy lot, at least as far as dental hygiene is concerned, because the south transept

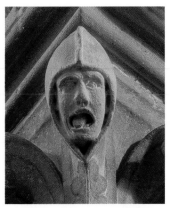

contains, as well as a delightful group of carvings depicting fruit stealing, a cluster of men with toothache. The most famous head, on the page opposite, looks as though he is in

agony, while the man on this page is exploring his mouth with his tongue, obviously searching for the cavity that is the source of his pain. It is easy to imagine the laughter that must have greeted the installation of these painful carvings, the apprentices probably laughing the loudest of all. The carvings are yet another indication of how, in the medieval cathedrals, the sacred and the profane often sat gumboiled cheek by carious jowl.

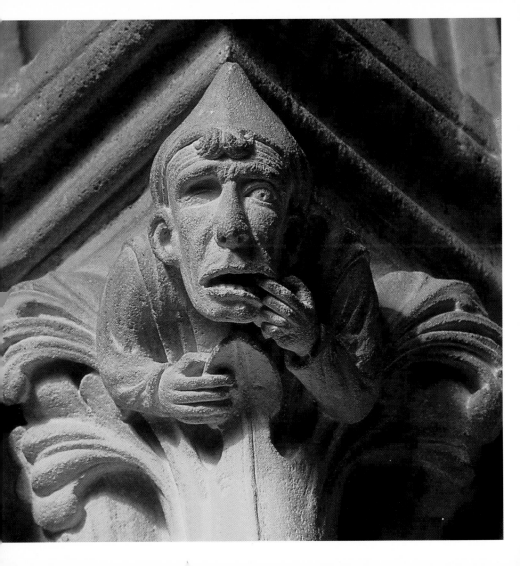

My thanks go to the Deans and Chapters of all the cathedrals whose treasures are featured in this book and likewise to all the vicars, vergers and enthusiastic helpers who gave me so much assistance. Draughty churches and chapels were opened for me and people went to great lengths to light my way in the darkness. Countless ladies gave me cups of coffee and tea and, with the exception of one man who is obviously unwell, I was shown nothing but kindness and courtesy by all those involved in the care and maintenance of the churches and cathedrals they so obviously love. I offer this book as my thanks to them and in praise of the men and women who created such great art to the glory of their God.

The camera used was a Nikon F3 with various lenses from 600mm to 20mm. The film throughout was Fuji Velvia. For difficult lighting conditions I used a hand-held video light.

The mischievous little chaps we see here sit high up on the High Street wall of Brasenose College Oxford, keeping one eye on the passers by down below.

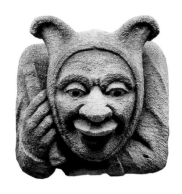

THE END